D1465825

JANE BOWN

CATS

JANE BOWN

CATS

Edited by
ROBIN CHRISTIAN

With special thanks to Jane's family,
Matthew Moss, Louisa Watkins and Hugo Moss.

Photographic reproduction and restoration: David McCoy,
Laurence Jenkins and the team at GNM Imaging.

Additional picture research: Philippa Mole,
Emma Golding and Helen Swainger, GNM Archive.

First published in 2016 by Guardian Books,
Kings Place, 90 York Way, London N1 9GU
and
Faber & Faber, Bloomsbury House,
74–77 Great Russell Street, London WC1B 3DA

Design and sequence by Friederike Huber

Printed in China

Copyright © the Estate of Jane Bown, 2016
Introduction copyright © Robin Christian

The right of Jane Bown to be identified as author of this
work has been asserted in accordance with Section 77
of the Copyright, Designs and Patents Act 1988

A CIP record for this book is available from the British Library

978–1–783–35087–2

2 4 6 8 10 9 7 5 3 1

For Sandy

Jean Cocteau, Paris, 1950 (*following page*)

BY THE SAME AUTHOR

Exposures
Faces
Unseen Bown
A Lifetime of Looking

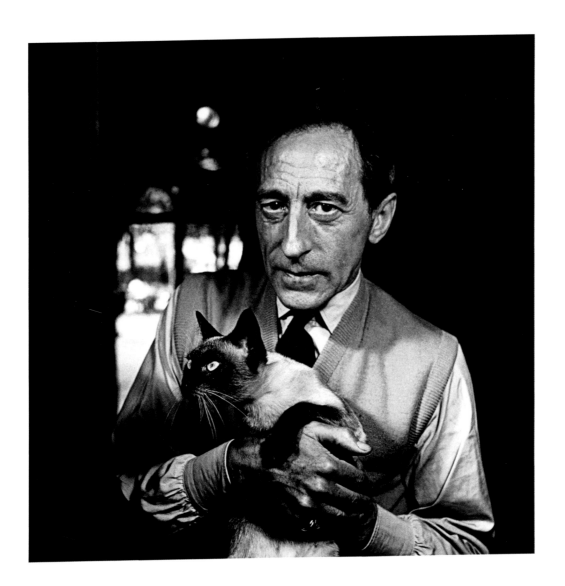

INTRODUCTION
Robin Christian

JANE BOWN was a photographer for the *Observer* for over six decades. She is best known for her iconic portraits of figures from the likes of Björk to John Betjeman, Samuel Beckett to Mick Jagger, and many of her pictures now reside in the National Portrait Gallery. Her gentle eye, her way of seeing, infuses her portraits with a unique candour and directness. In this collection, she turns her attention from people to cats. The photographs in this book were compiled after her death in 2014. Many of them are previously unseen and showcase a more private and mischievous side to Jane's work.

The images that make up *Cats* were discovered at the beginning or end of Jane's rolls of film, so we know that she quietly assembled much of this affectionate study on her way to or from an *Observer* assignment. Jane described herself as a 'one-shot photographer' and went about her work with little fuss and at a great speed. You can imagine how this helped her with reluctant feline subjects. Whether she photographed these cats sleek and pampered at a show, snapped them through a window as she passed by, or caught them perched on a tombstone or high tree branch, her approach is arguably 'cat-like'; we can imagine her prowling, pouncing rapidly in order to capture them. Jane knew that the secret to a good portrait was in the eyes, and time and again you

see recognition between the feline subject and photographer (from Gabby the family cat on page 33) as well as warmth (such as the lovely heart-shaped duo on page 53). On receiving a new set of negatives she would cut out her favourites from these encounters as single frames and place them within the 'Animals' section of her collection – now housed and preserved at the GNM Archive, which collects the records of the *Guardian* and *Observer* newspapers. Jane rarely dated these negatives and the 'series' (which blurs the boundaries of 'work' and family 'snaps') was very much made for her own pleasure.

I relished the opportunity to discuss Jane's work with her when I began to catalogue her collection in 2007. With each brown archive box opened came a new set of questions, and, more often than not, wonderful stories in response. Jane was remarkably modest and approachable; she famously described herself as 'just a hack', and once, when wedged against some prints in the back of a car on the Farringdon Road, she told me about her first trip to Paris to photograph the artist and writer Jean Cocteau. 'I was twenty-four and had never been to France, so with the cheek of youth I put a proposition to the *Observer*. If they paid my expenses I would go to Paris (not speaking a word of French) and photograph four people – it was quite an escapade really.' In Paris, Jane took seven frames of Cocteau on her beloved Rolleiflex camera, including two with his cat, Madeline. Jane sent a set of prints back to Cocteau, whose swift admiring reply thanking her for the 'beautiful prints' noted her rare ability to 'think' about her subject. Cocteau added Madeline's gratitude to his own; she had been admiring herself!

In the *Observer* office she was known as 'Tenacity Jane' because she never came back from an assignment without the shot. She cut quite an unusual figure in the predominantly male newsrooms of the 1960s and 70s. The photographs in *Cats* reveal another side to Jane – that of a wife and mother, and her life in the family home where she was known as Mrs Moss and seldom discussed her work (she always said she became Jane Bown on the train to London). Even here, whether at Vine

Cottage in Kent or, later, Parsonage Farm in Hampshire, she was never too far from a camera to capture Spats, Queenie, Tom Gosling, Tammy and others in the great dynasty of family cats acquired and born throughout Jane's life. Her last pet, Mona, an adoring rescue cat, was Jane's constant companion throughout her final days in Alton, Hampshire.

The photographs in *Cats* were made over five decades, and this book forms only a small part of a subject she returned to time and time again. Jane's admiration and respect for her feline subjects is striking. These are dignified studies made in what Jane would describe as a 'good light', but never cute or sentimental. Jane clearly enjoyed the company of cats, and it is this affection which binds these quiet moments together.

'Once you've owned a cat you are hooked forever.'

Cat Action Trust, London, 1980
(*opposite and following pages*)

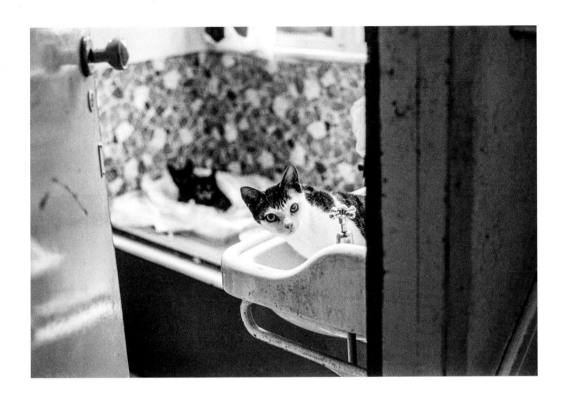

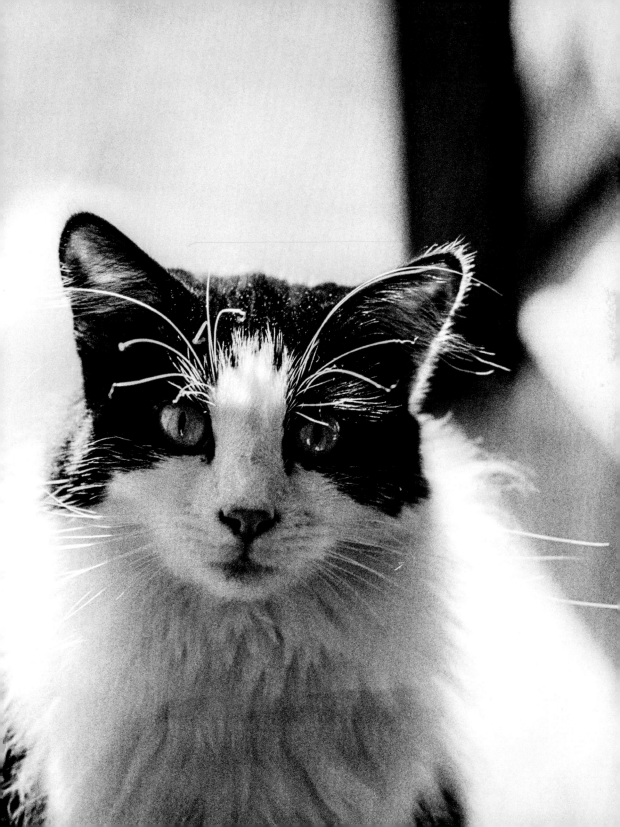

Queenie, Sevenoaks, 1967

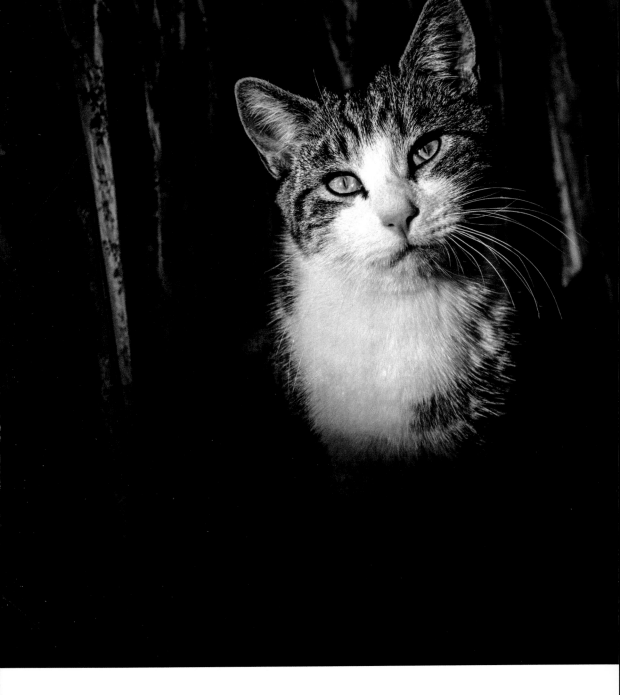

Tombola, Tom Gosling and Tammy,
Hampshire, *c.*1985

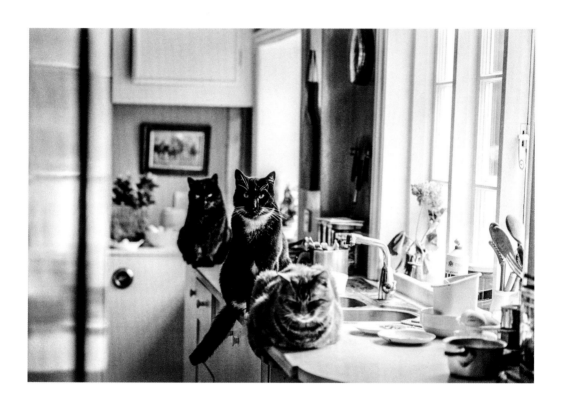

Parsonage Farm, Hampshire, *c.*1995

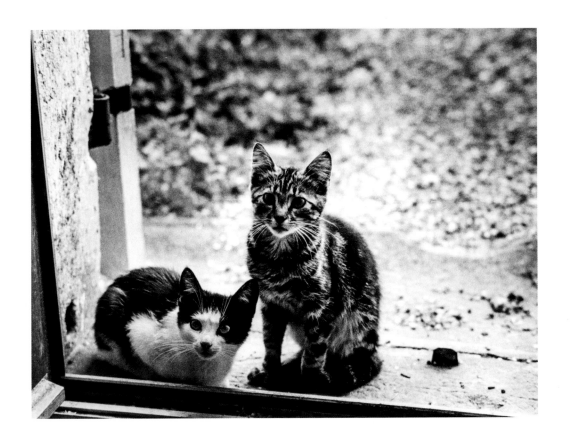

David Knopfler's kitten, 1979

Julian Trevelyan's studio cat, London, *c*.1985 (*following pages*)

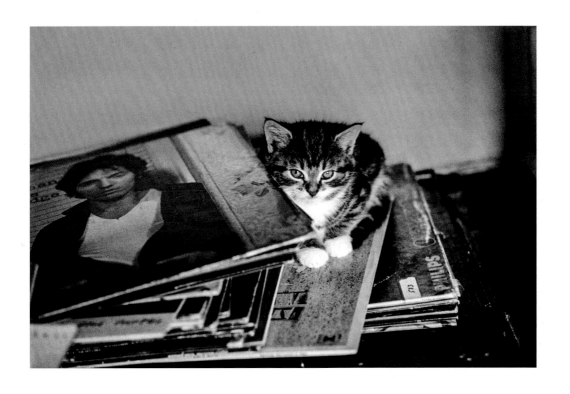

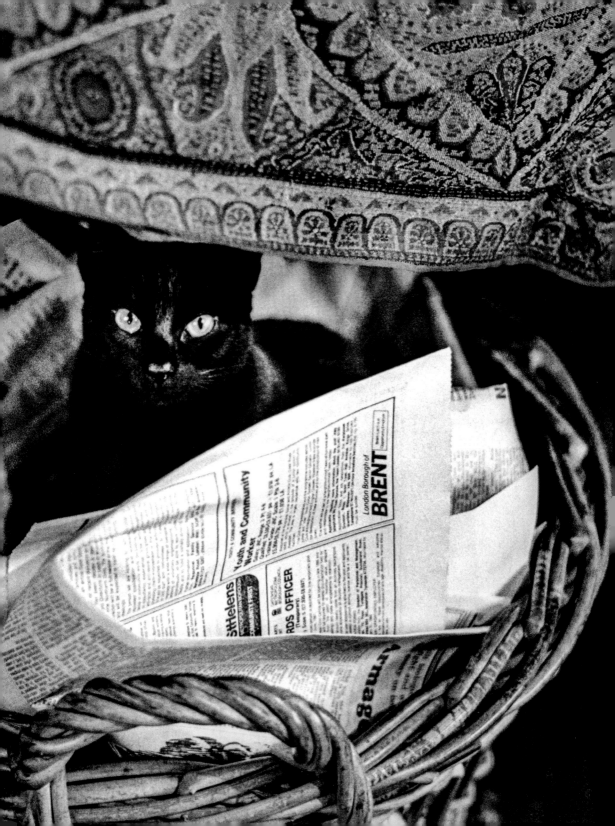

Cat home, London, *c.*1965

Queenie and Dusty, Sevenoaks, 1967 (*following pages*)

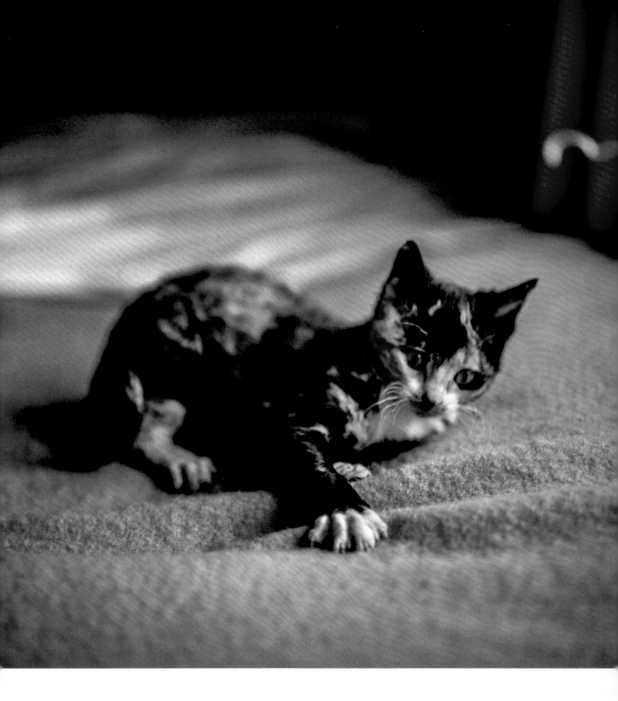

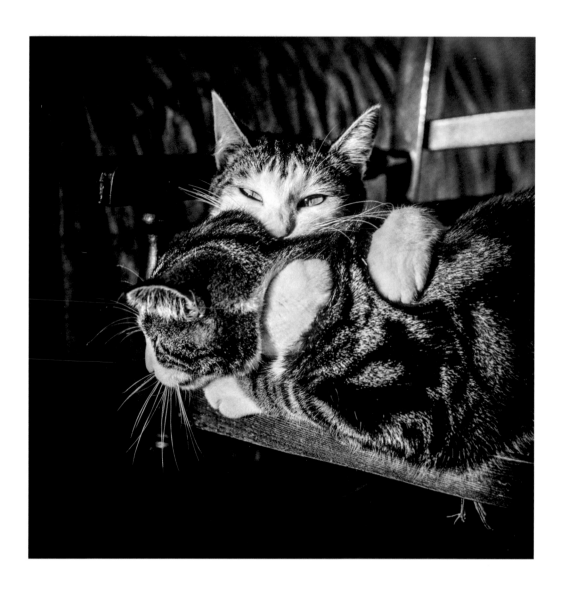

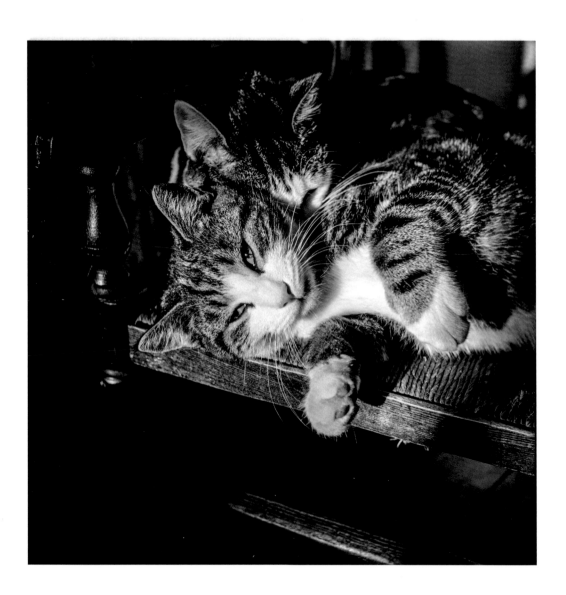

Gabby, Kent, 1967

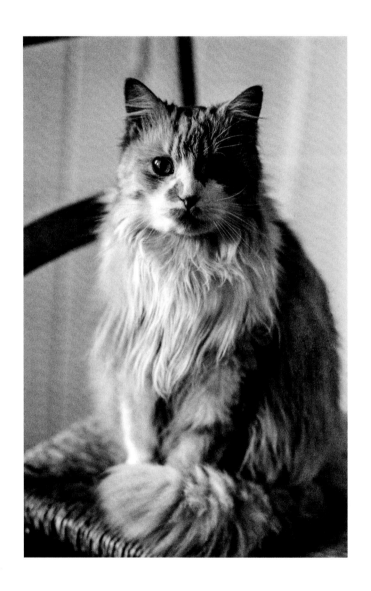

Penzance, *c.*1960

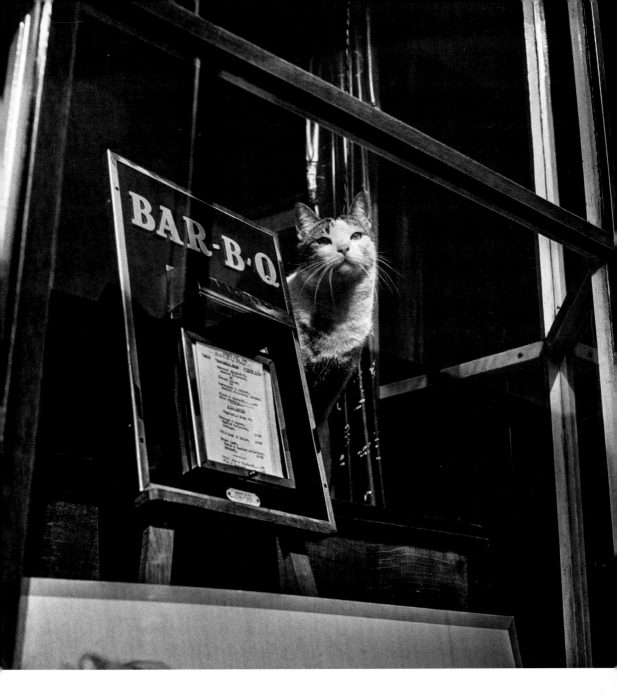

Laughing cat, Italy, 1985

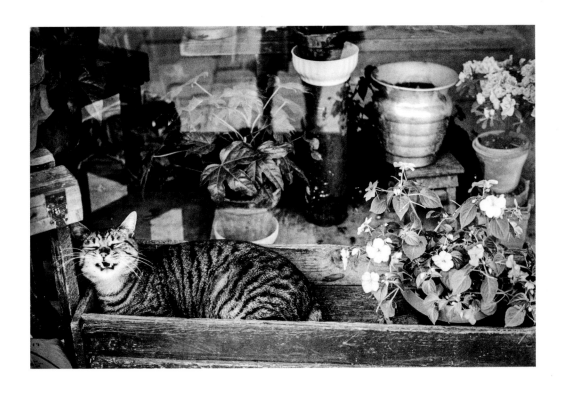

Cat show, Olympia, 1976

London, *c*.1992 (*following pages*)

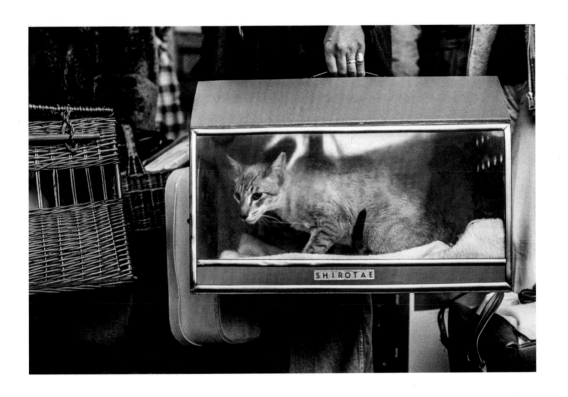

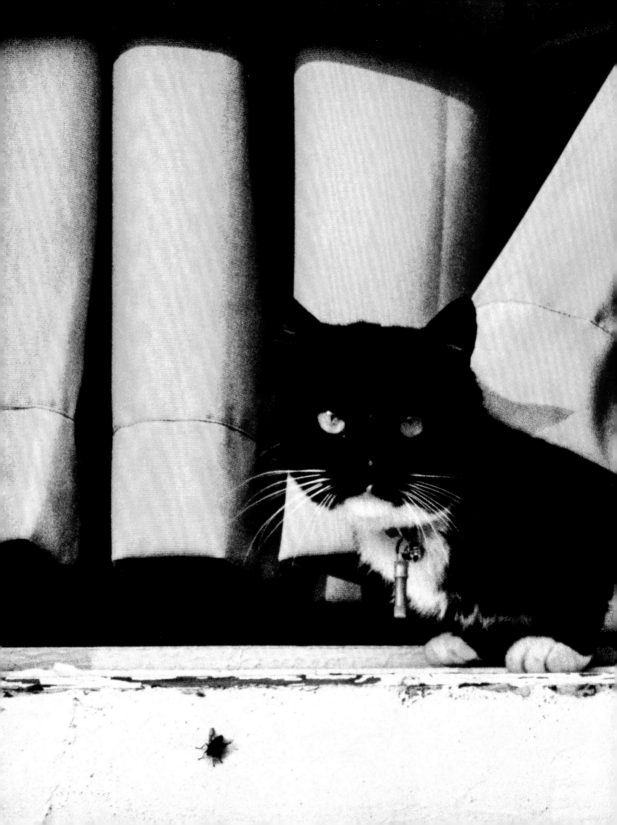

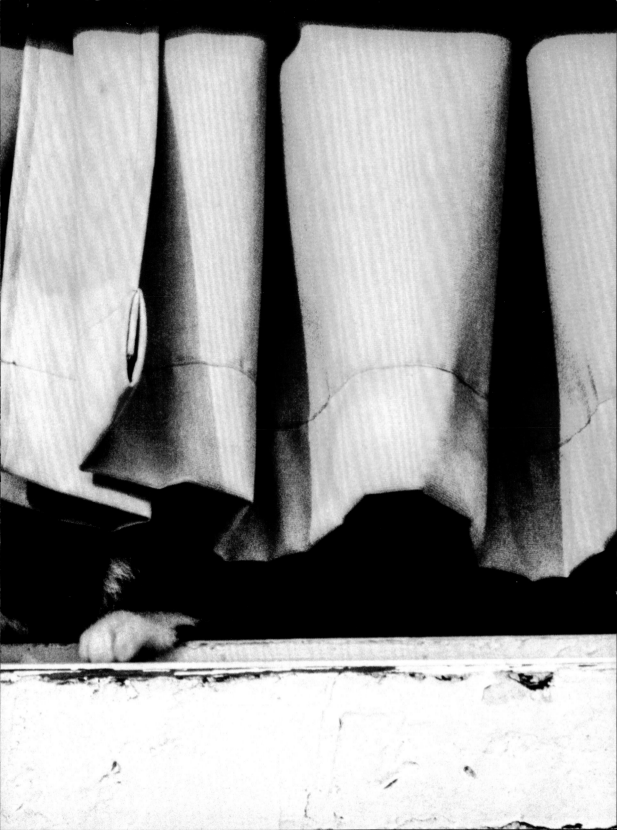

London, *c*.1991

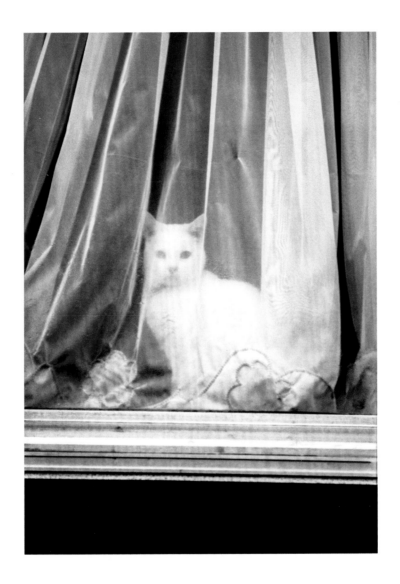

Cat show, London, *c*.1977

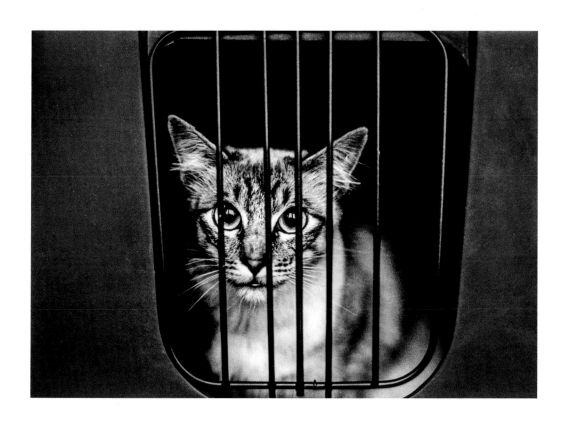

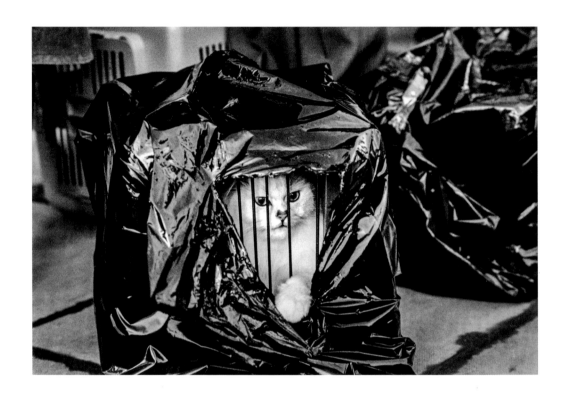

Cat show, London, 1982

Show cat in travelling basket,
National Cat Club Show, 1976 (*opposite*)

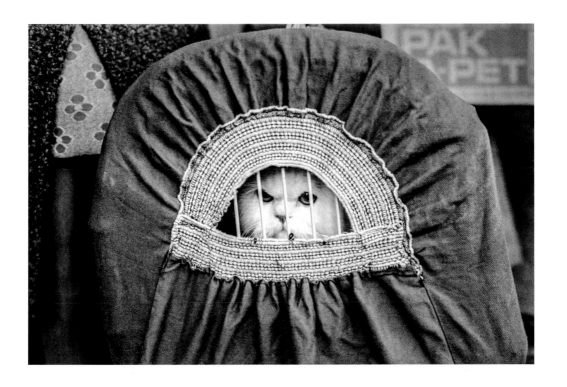

Reading, *c.*1983

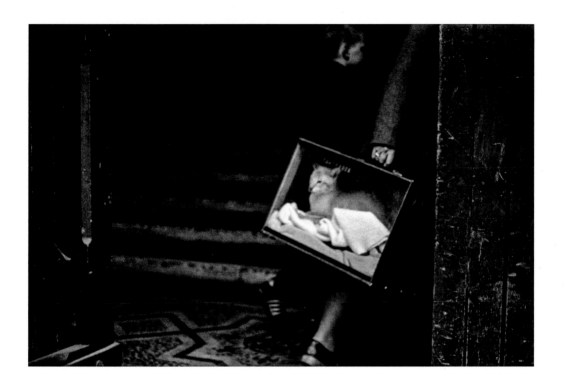

Show cat, Olympia, London, 1982

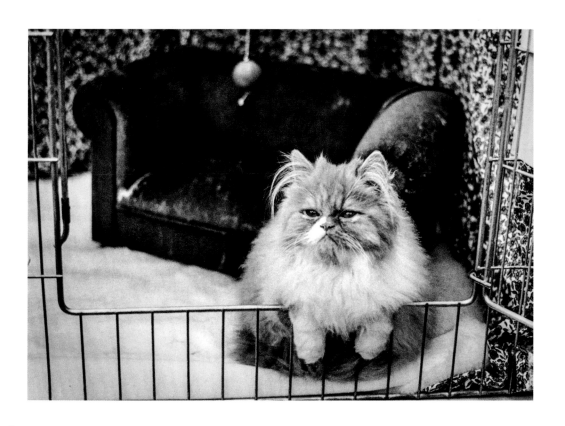

Show cats, National Cat Club Show, 1983

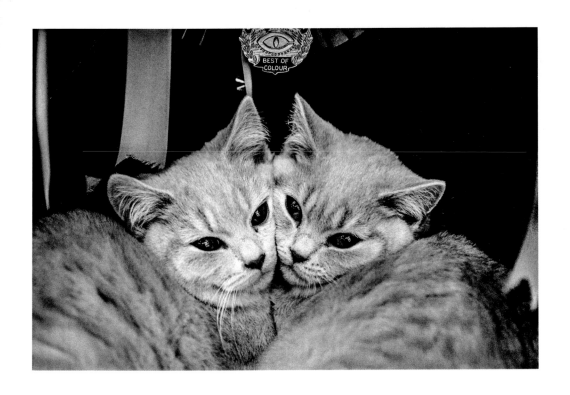

Cat show, London, 1982

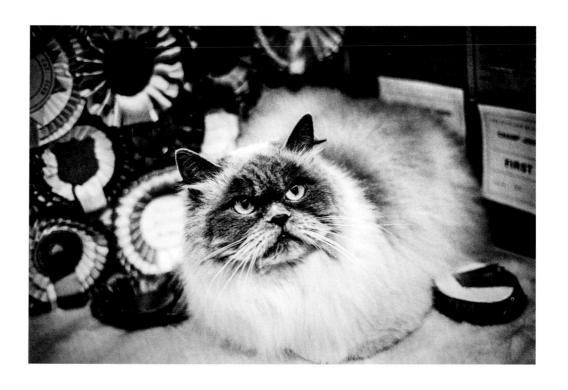

The First Supreme Cat Show, London, 1976

Cat show, London, 1982 (*following pages*)

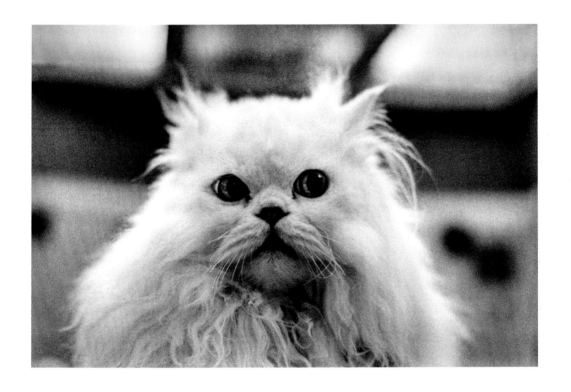

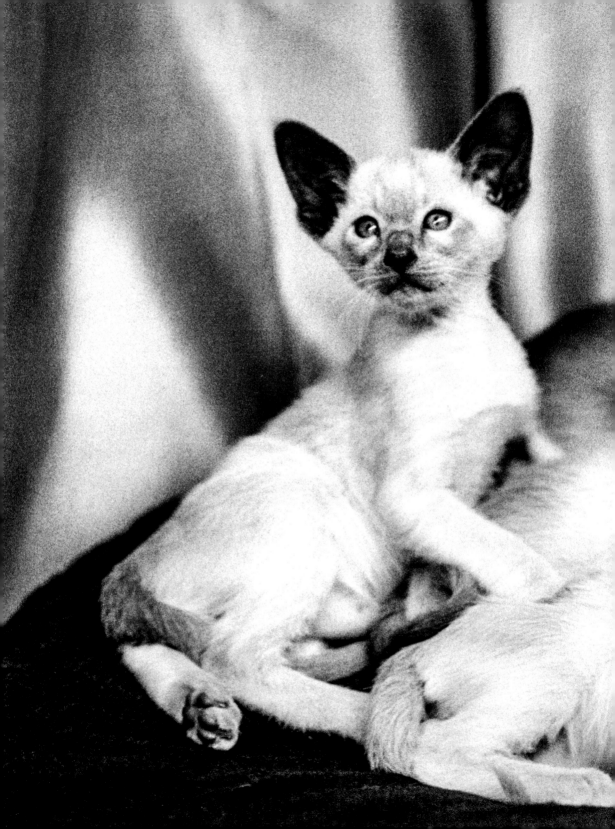

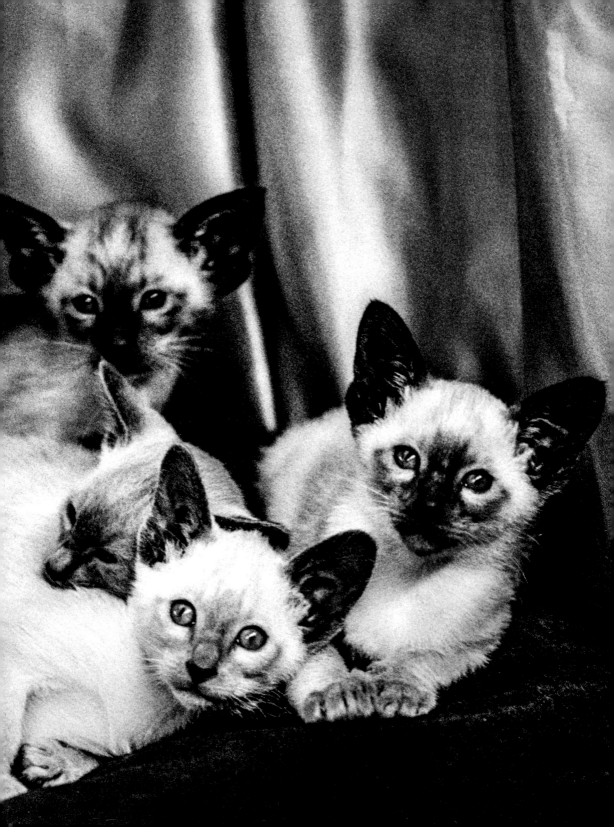

National Cat Club Show, London, 1985

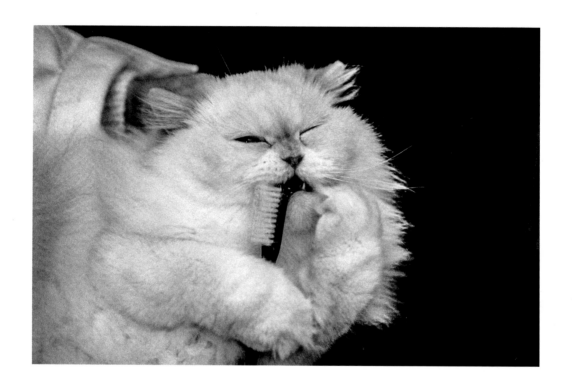

Siamese Cat Society Show, Reading, 1983

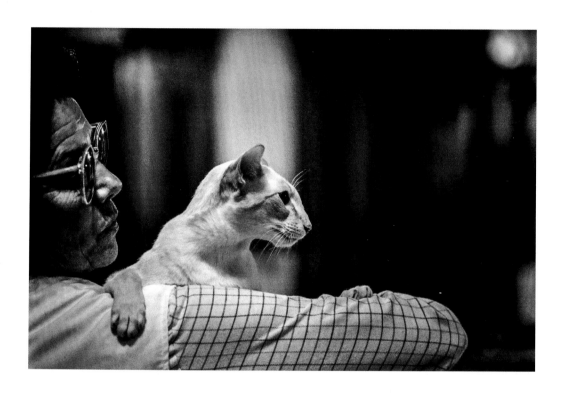

Cat home, London, *c*.1964

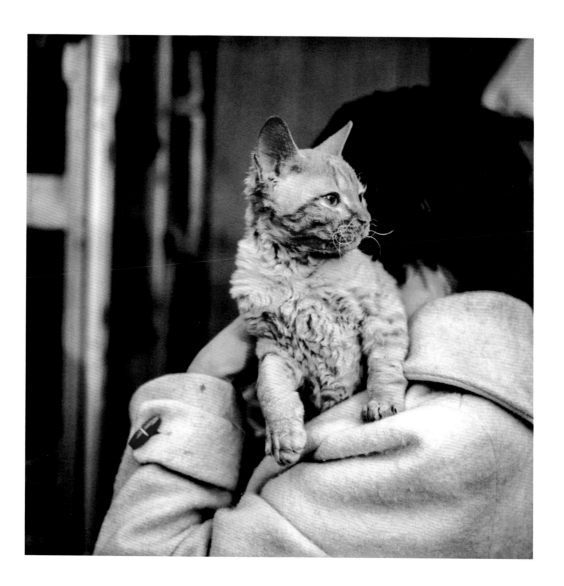

Amalfi Coast, Italy, 1956

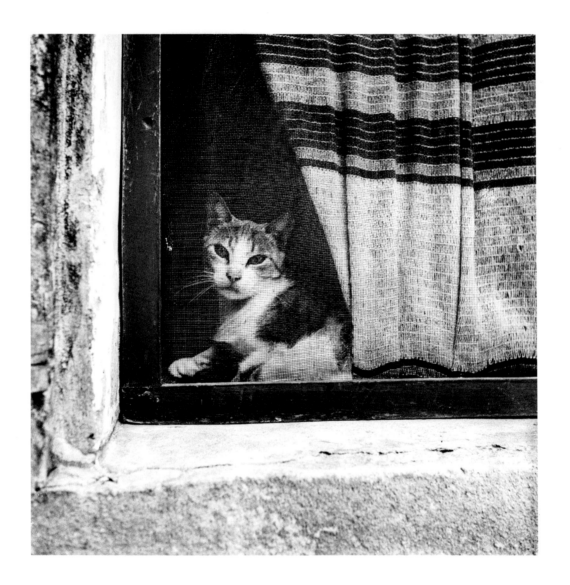

In quarantine, 1970

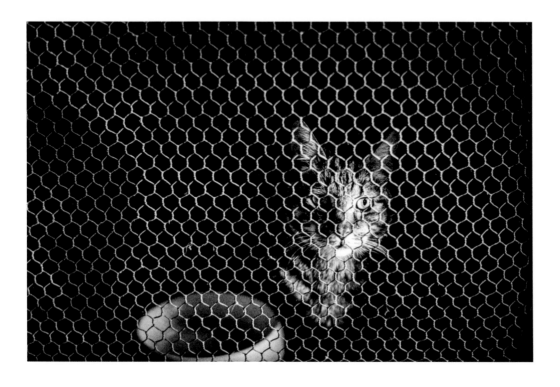

Rome, *c.*1960

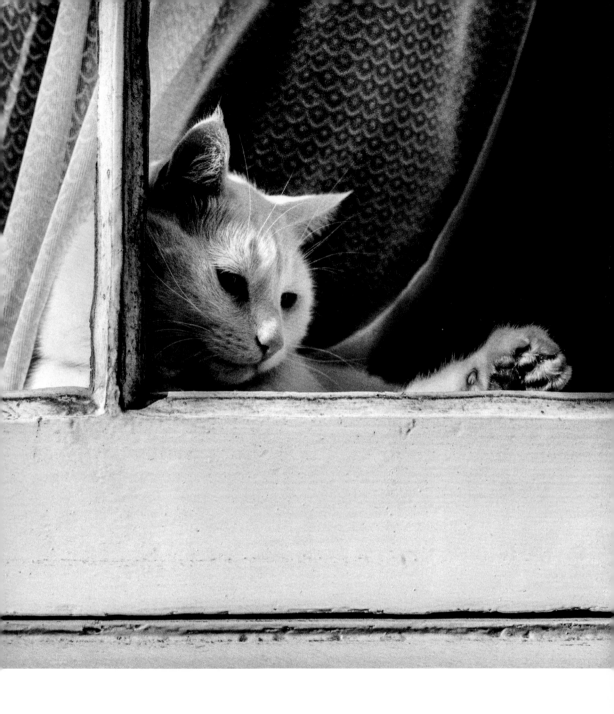

Tom Gosling, Hampshire, *c*.1993

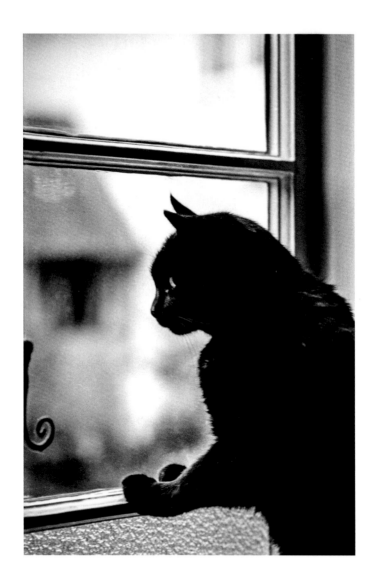

Cat home, London, 1979

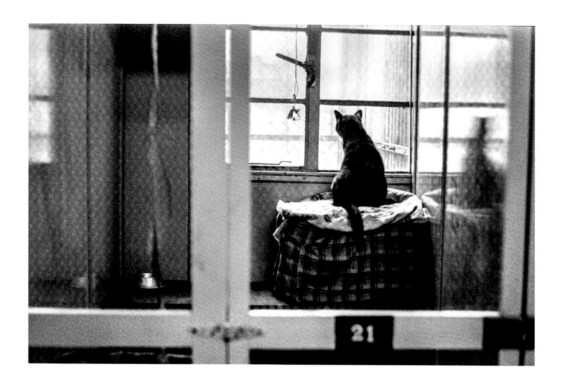

Hampshire, *c.*1987

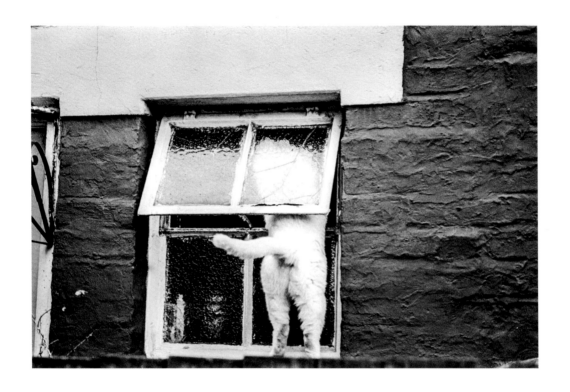

Vine Cottage, Kent, *c.*1970

Tombola, Hampshire, *c*.1986

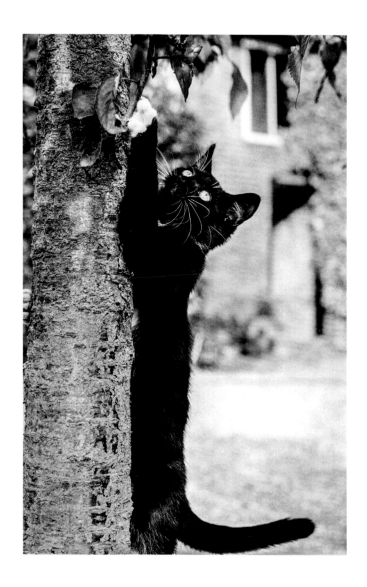

Parsonage Farm, Hampshire, *c.*1992

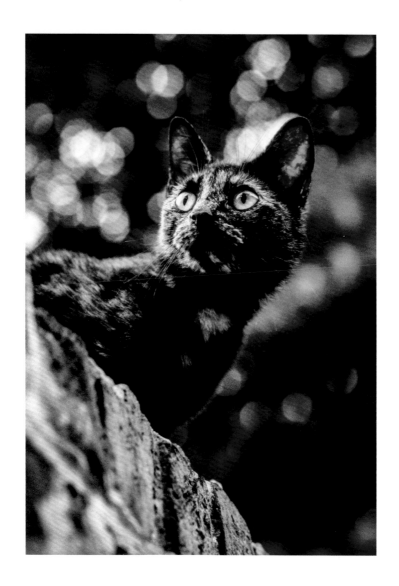

Spats, Hampshire, 1983

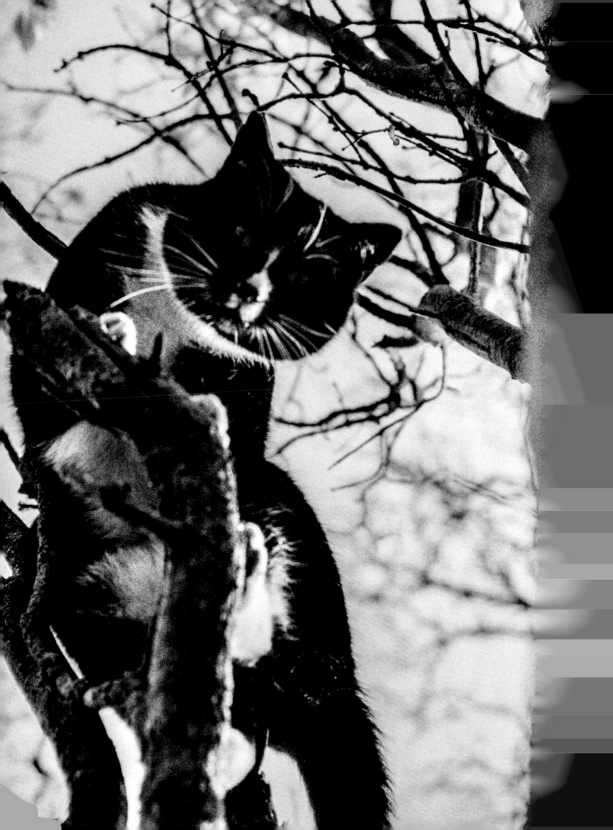

Moppet, Kent, 1969

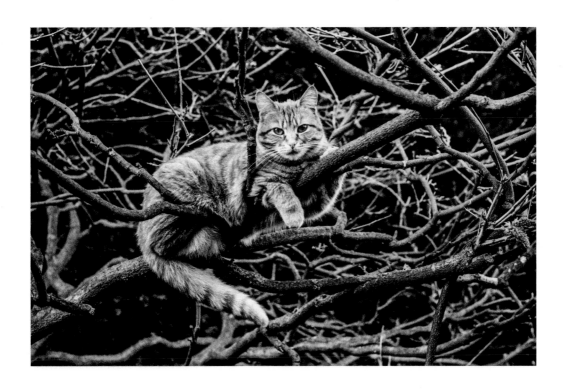

Tammy, Hampshire, *c.*1986

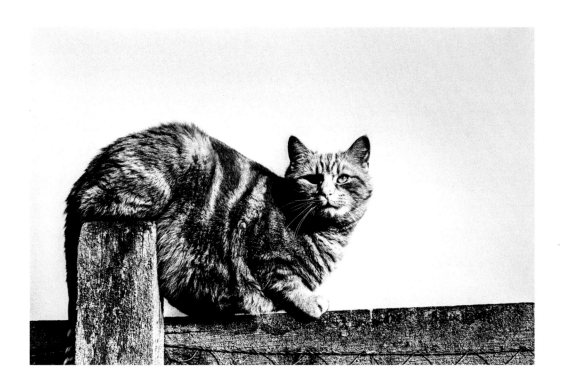

London, *c*.1965

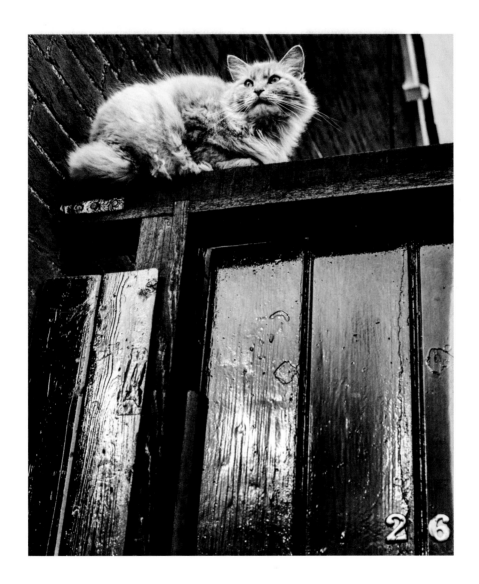

Parsonage Farm, Hampshire, *c.*1992

Spats, Parsonage Farm, Hampshire, *c.*1992 (*following pages*)

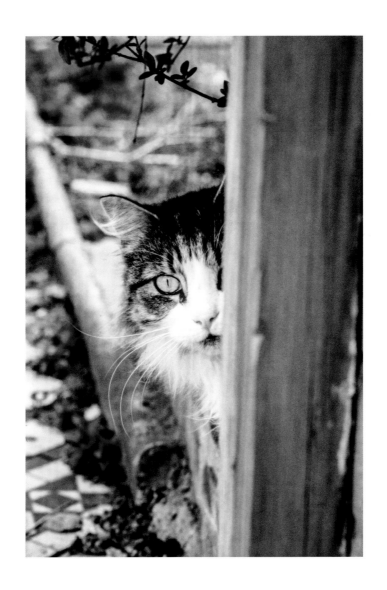

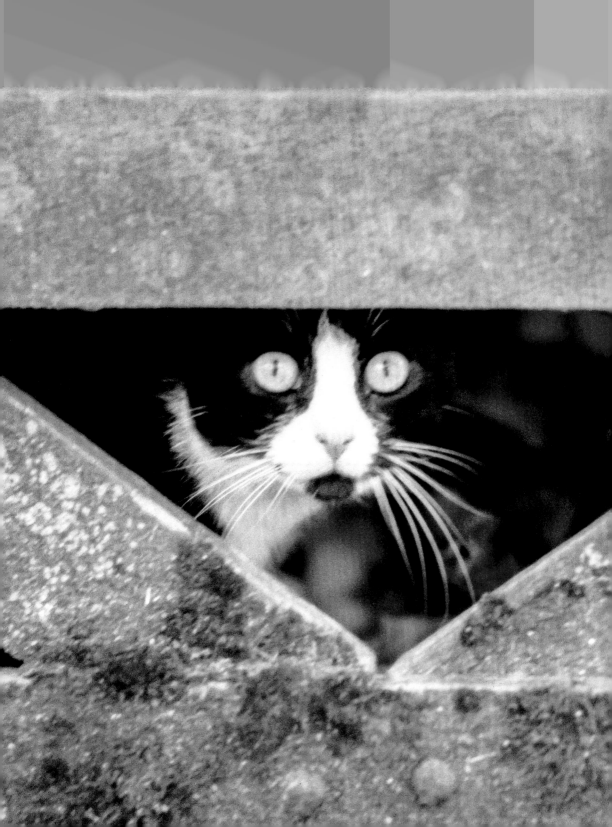

Penzance, *c.*1960

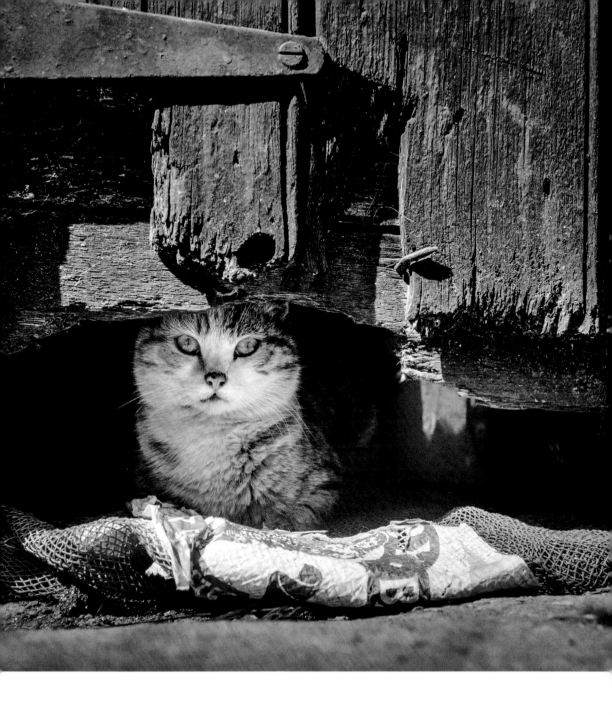

Tombola, Hampshire, *c.*1985

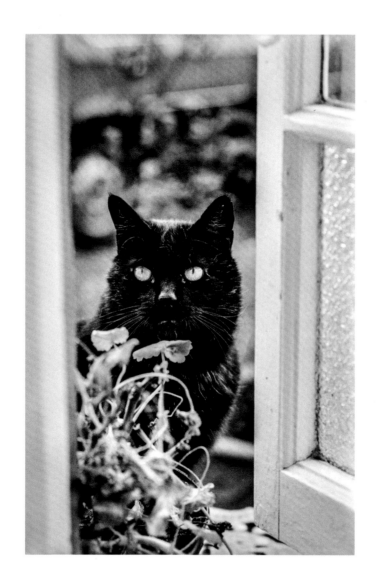

Newport, South Wales, 1983

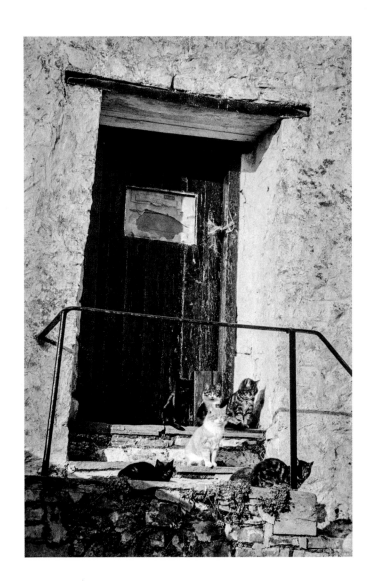

Queenie, Kent, 1964

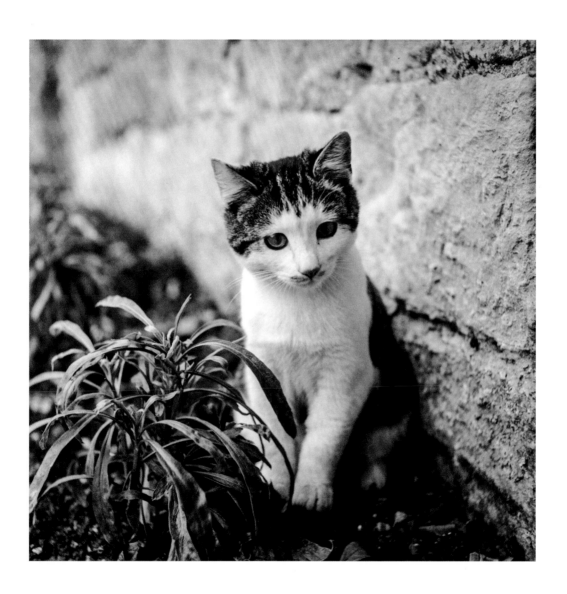

Trilby, in old age, Hampshire, *c.*1993

Queenie, Hampshire, *c.*1993
(*following pages*)

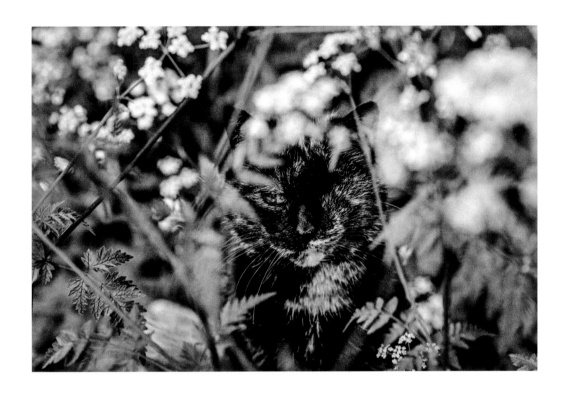

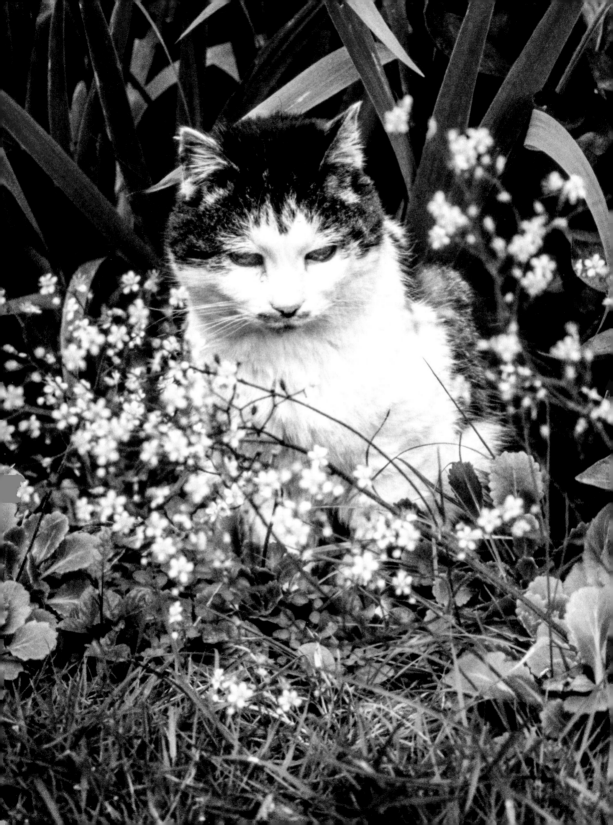

Italy, 1964

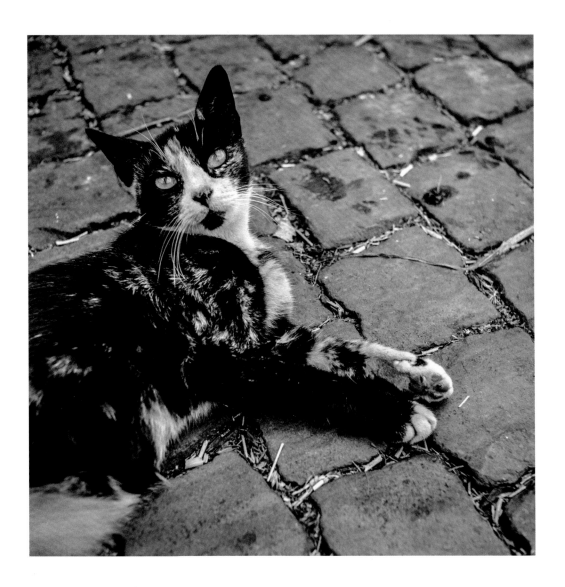

Solemn cat, Hampshire, c.1966

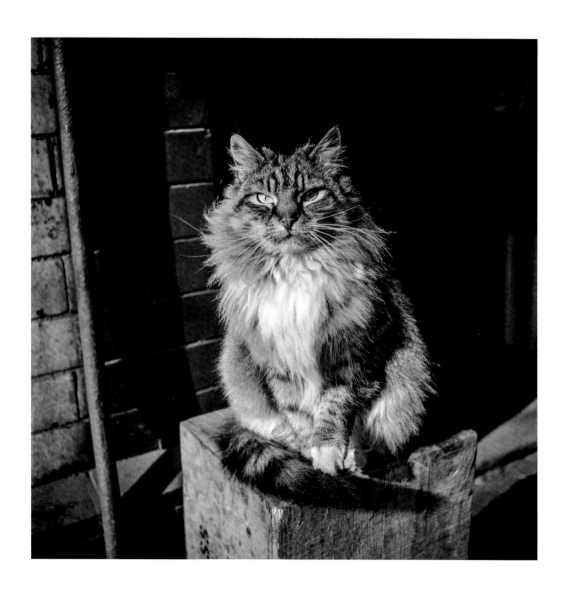

Performing cat, La Rochelle, *c.*1985

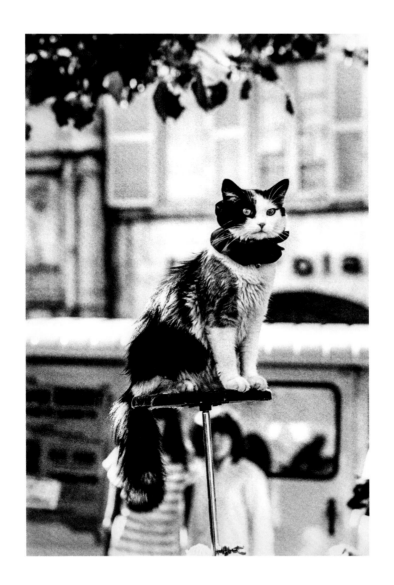

Tammy in a good light, Hampshire, *c.*1985

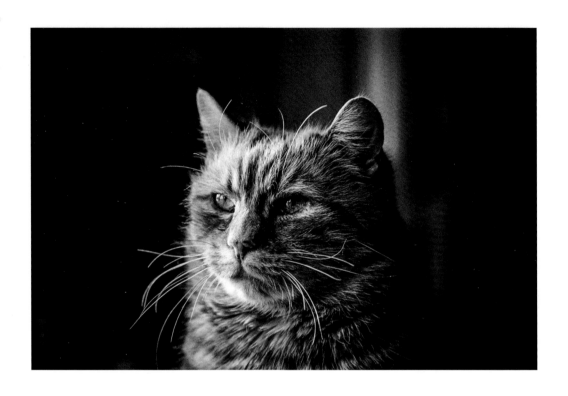

Station cat, King's Cross, London, *c.*1979

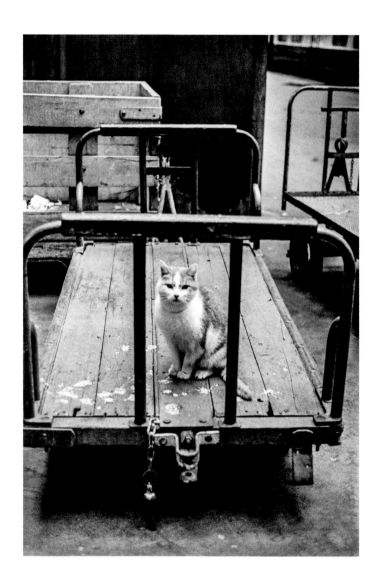

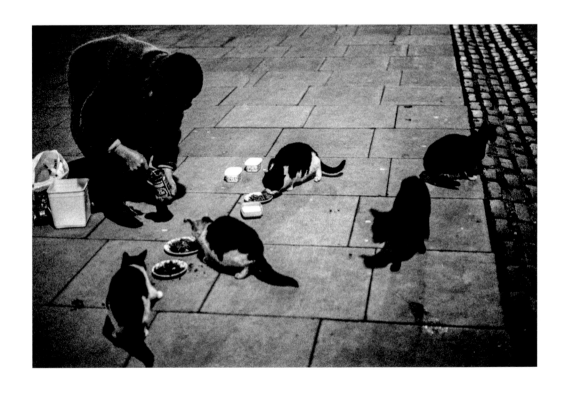

Miss Wyatt, who had been feeding cats in Fitzroy Square since 1953,
taken in 1978

King's Cross, London, *c.*1979 (*opposite*)

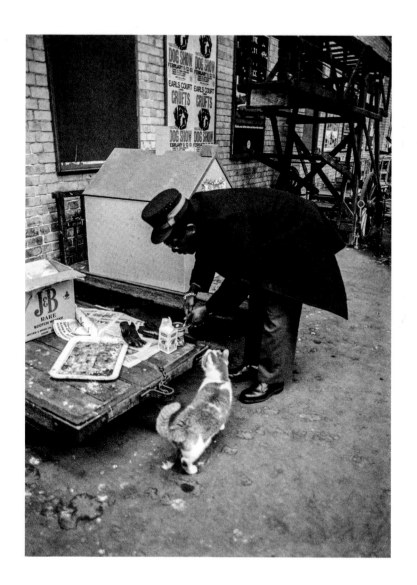

London, *c.*1969

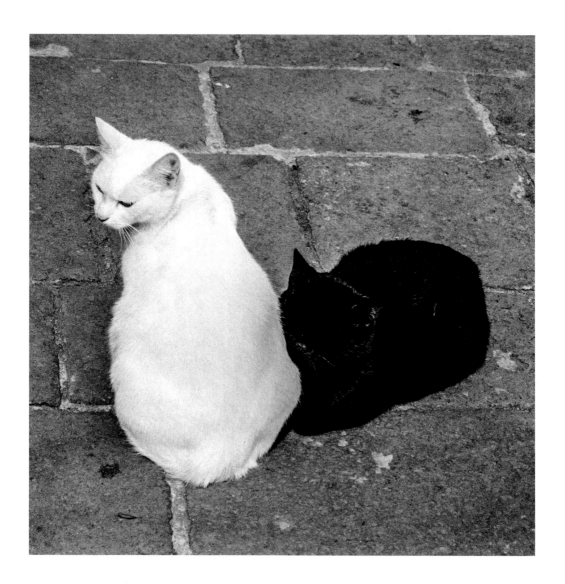

Reclining in Soho, *c.*1972

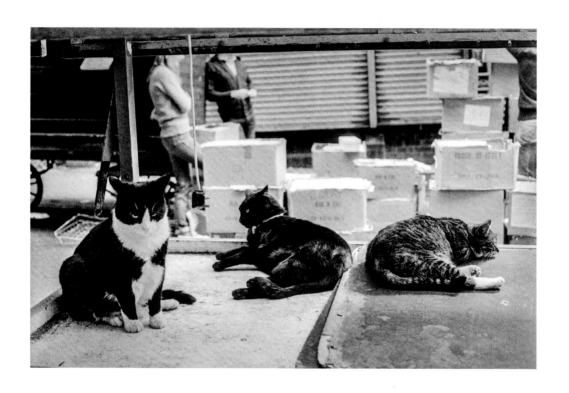

Hampshire, *c*.1995

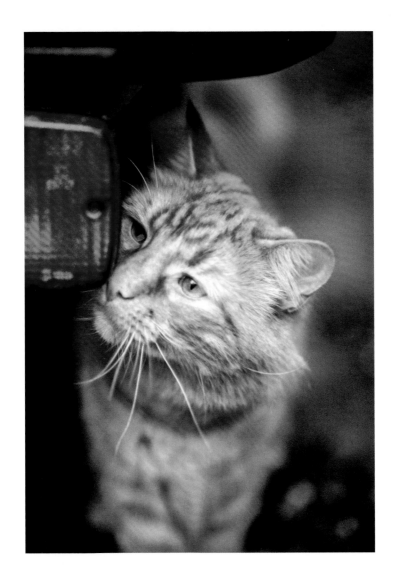

Spats, Kent, 1974

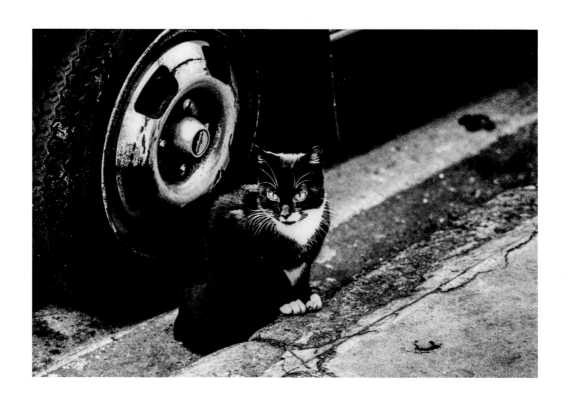

Fulham Broadway, London, 1978

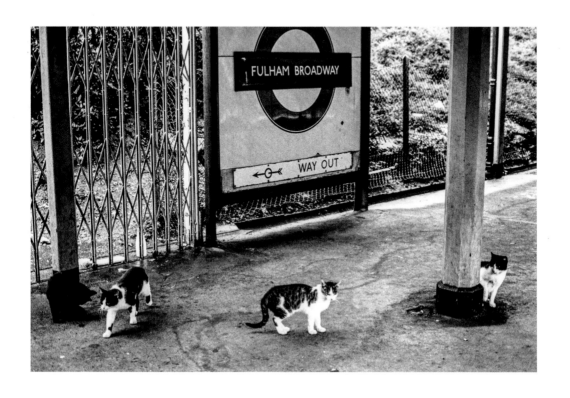

Scavenging outside the station,
Fulham Broadway, London, c.1979

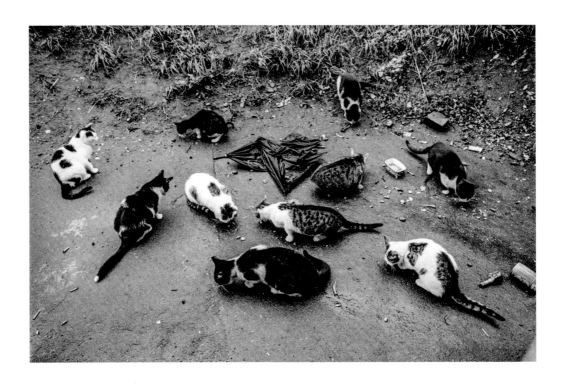

On the quay at Cawsand, Devon, *c.*1976

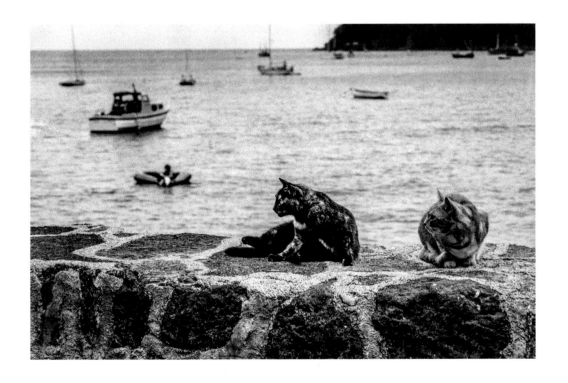

Fish market, Milford Haven docks, 1979

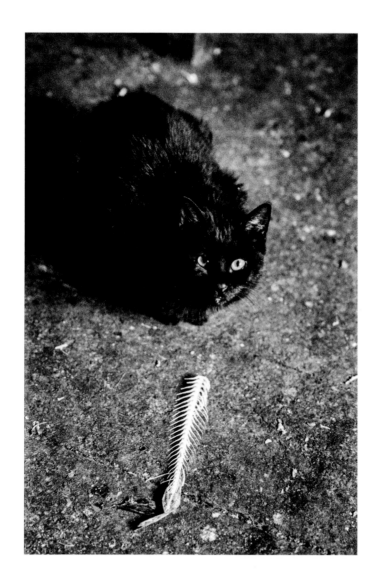

Busby, Lasham graveyard, *c.*1994

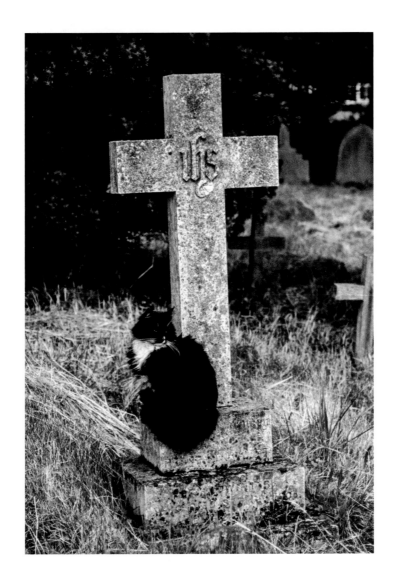

Tammy, or Tam O'Shanter, Lasham House,
Hampshire, *c.*1985

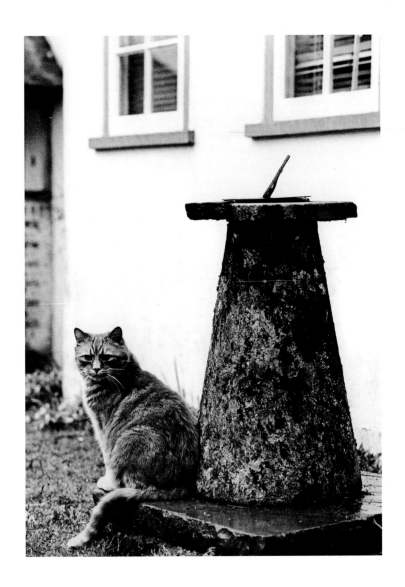

Parsonage Farm, Hampshire, c.1992

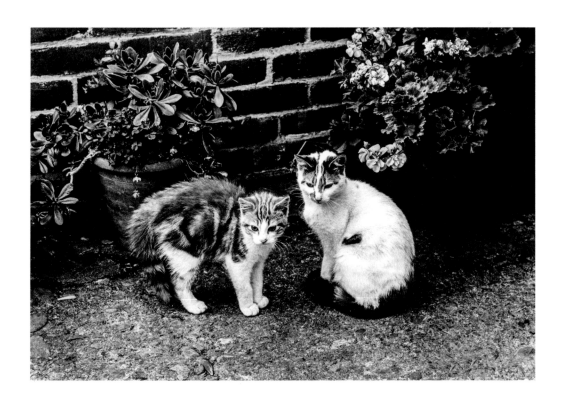

Vine Cottage, Kent, *c.*1975

Trilby with kittens, Hampshire, *c.*1980 (*following pages*)

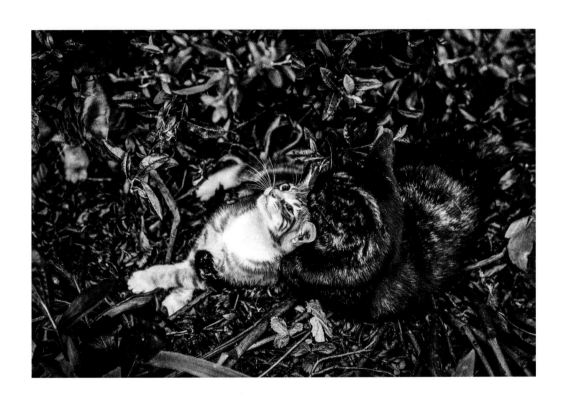

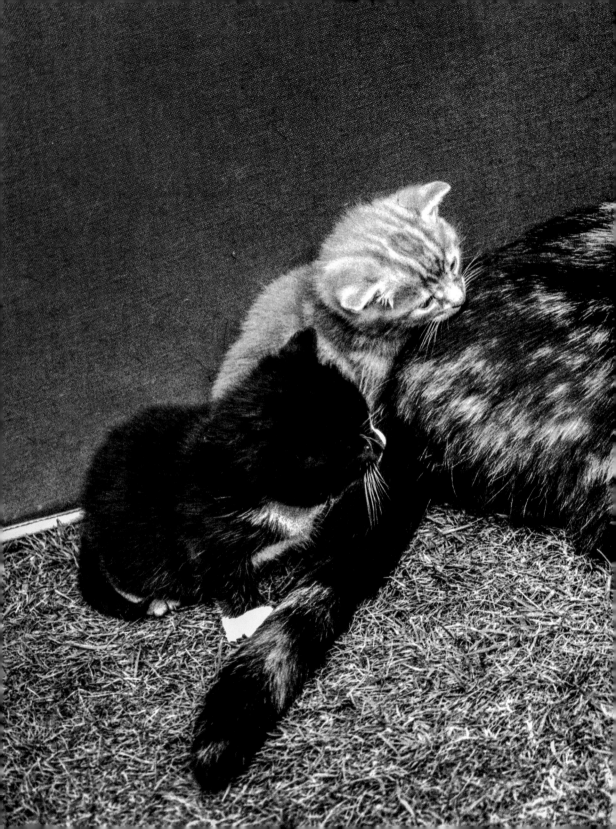

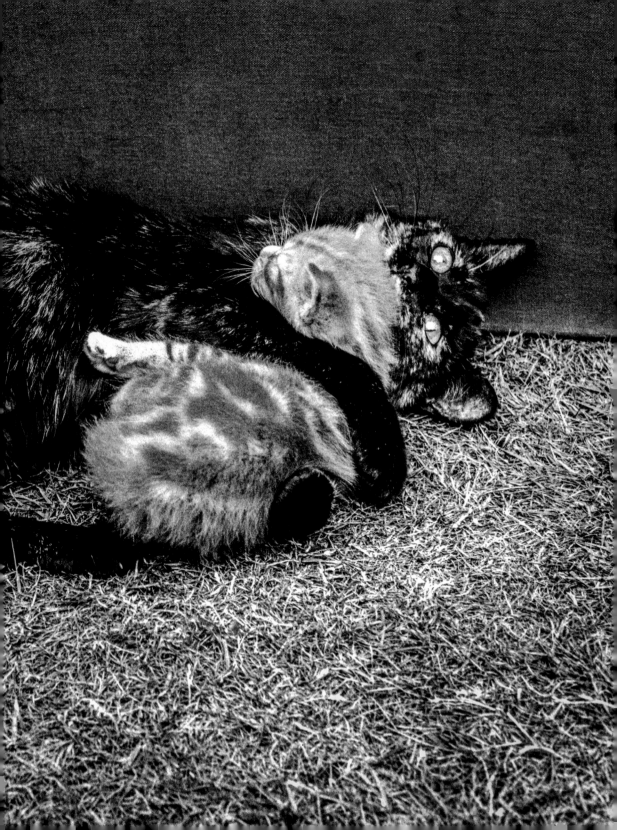

Trilby with kitten, Hampshire, *c.*1980

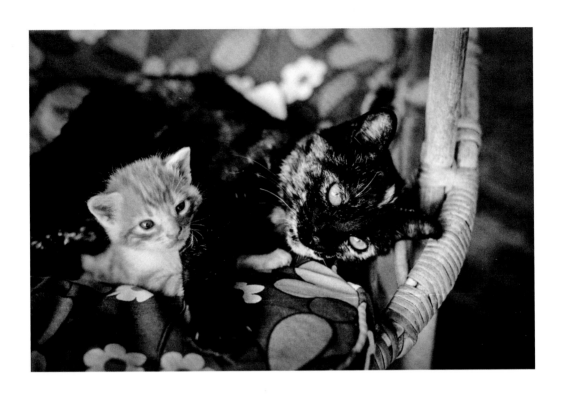

Coventry, *c.*1990

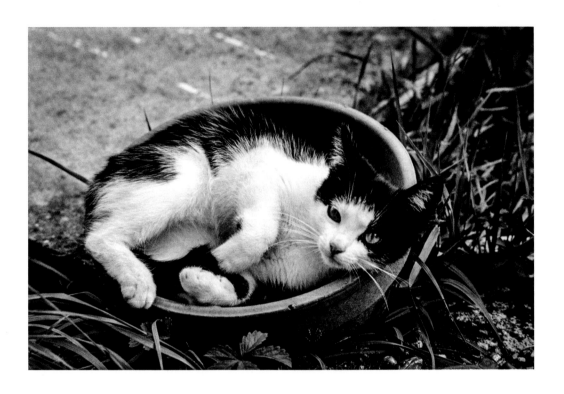

Queenie, Kent, 1975

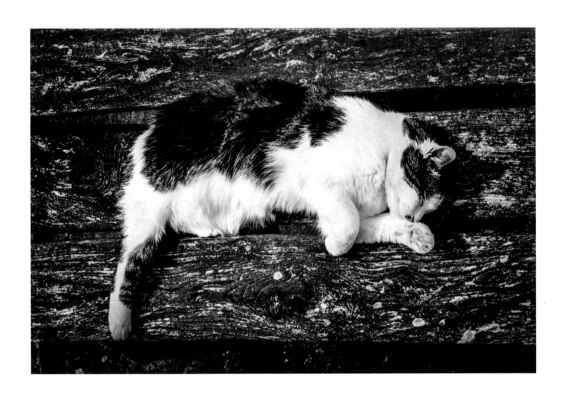

Spats and friends,
Parsonage Farm, Hampshire, *c.*1994

Vanessa and Alex, Kent, 1973 (*following pages*)

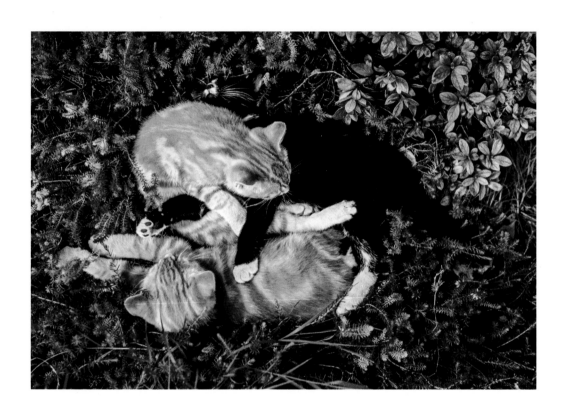

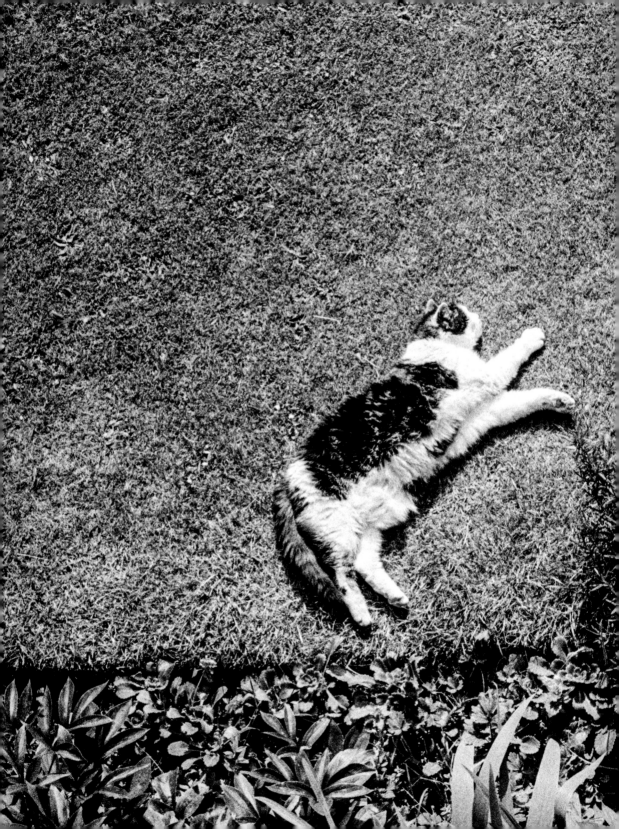

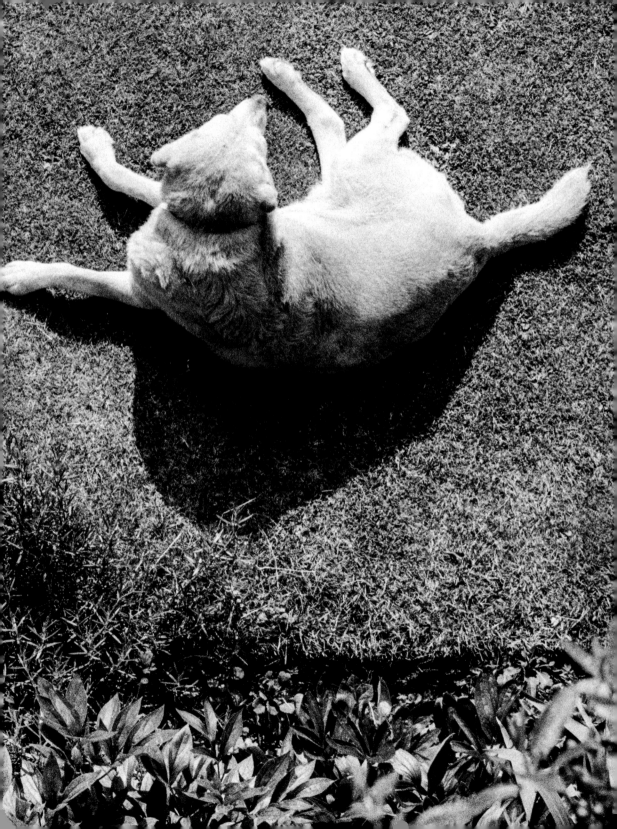

Lounging cat, Hereford, *c.*1988

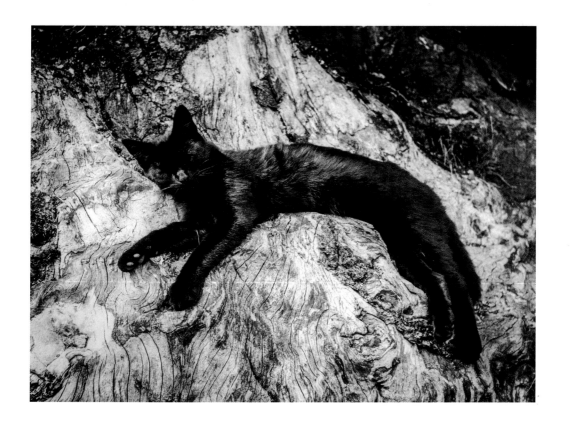

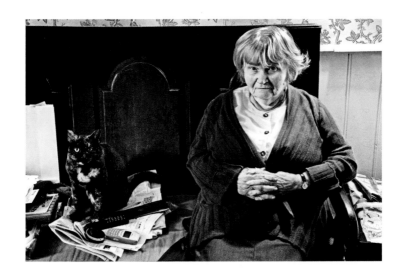

Jane and Mona, The Old House, Alton, 2011
taken by Hugo Moss